SELF-LOVE CLUB

SELF-L♥VE CLUB

REAL TALK AND REMINDERS FOR DISCOVERING THAT WE'RE ENOUGH

HYESU LEE

CHRONICLE BOOKS
SAN FRANCISCO

Library of Congress Cataloging-in-Publication Data
available.

ISBN 978-1-7972-2491-6

Manufactured in China.

Design by Allison Weiner.

10 9 8 7 6 5 4 3 2

Chronicle books and gifts are available at special
quantity discounts to corporations, professional
associations, literacy programs, and other organiza-
tions. For details and discount information, please
contact our premiums department at corporatesales@
chroniclebooks.com or at 1-800-759-0190.

Chronicle Books LLC
680 Second Street
San Francisco, California 94107
www.chroniclebooks.com

THIS BOOK IS FOR ALL OF YOU,
WHO DESERVE LOVE. ♡

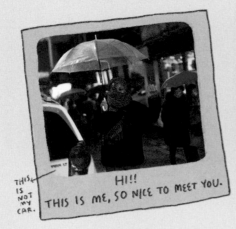

THIS IS NOT MY CAR.

HI!!
THIS IS ME, SO NICE TO MEET YOU.

I LOVE WHAT I DO...FROM AS SOON AS I GET UP TILL LATE AT NIGHT! AND I HAVE THE WORST POSTURE. ☺

I'M FROM SOUTH KOREA, NOW LIVING & WORKING IN BROOKLYN.

I ALSO LOVE FOOD (ALMOST AS MUCH AS ILLUSTRATION) AND I'LL EAT MY NOODLES WITH TWO TOOTHBRUSHES IF I HAVE TO. NOTHING CAN STOP ME. ☺

I'M A HUGE ANIMAL LOVER, ESPECIALLY BIG SUCKER FOR DOGS.

SO IF YOU GET ME A DRINK IN A DOG GLASS, I'M ON CLOUD NINE!

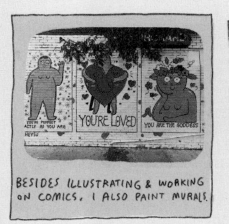

BESIDES ILLUSTRATING & WORKING ON COMICS, I ALSO PAINT MURALS.

I ALSO ~~TEACH~~ ILLUSTRATION.

MY PARTNER IN CRIME IS ALSO AN ILLUSTRATOR, AND WE LOVE TO DRAW POOP TOGETHER!

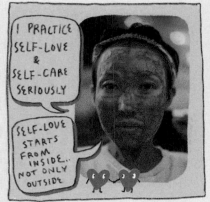

I PRACTICE SELF-LOVE & SELF-CARE SERIOUSLY

SELF-LOVE STARTS FROM INSIDE... NOT ONLY OUTSIDE

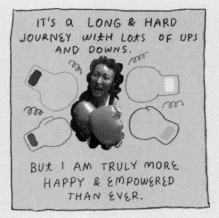

IT'S A LONG & HARD JOURNEY WITH LOTS OF UPS AND DOWNS.

BUT I AM TRULY MORE HAPPY & EMPOWERED THAN EVER.

AND I'D LOVE FOR YOU ~~to~~ JOIN ~~the~~ SELF-LOVE CLUB ~~to~~ GO ON ~~this~~ JOURNEY TOGE~~t~~HER!!

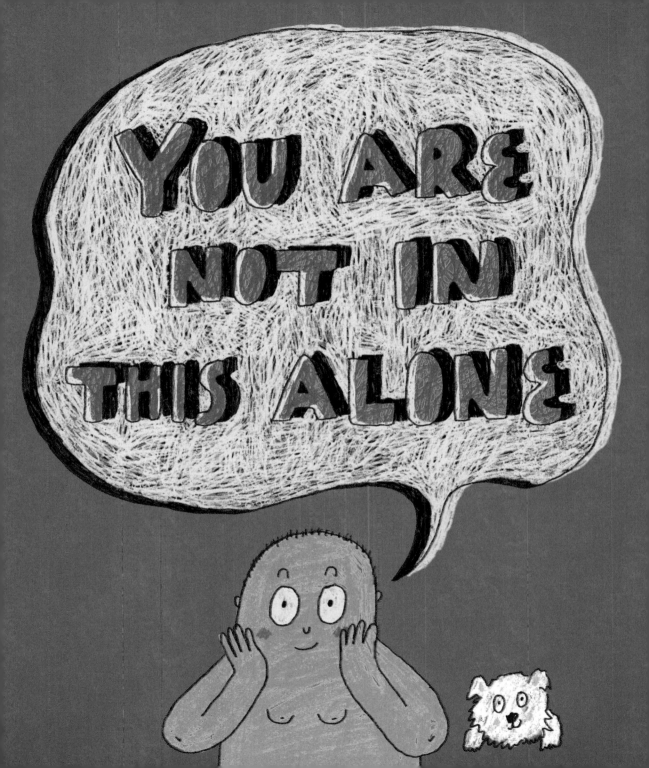

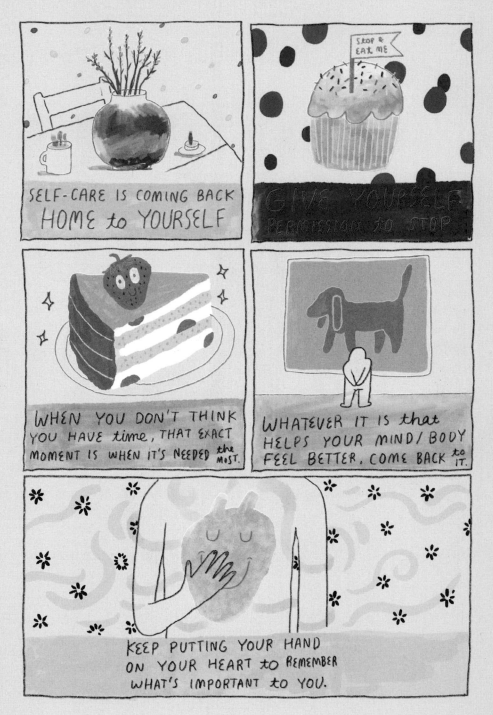

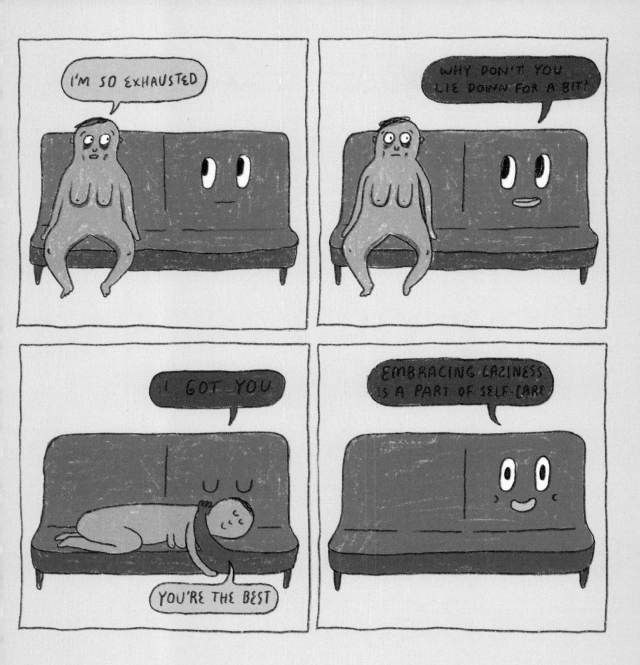

11

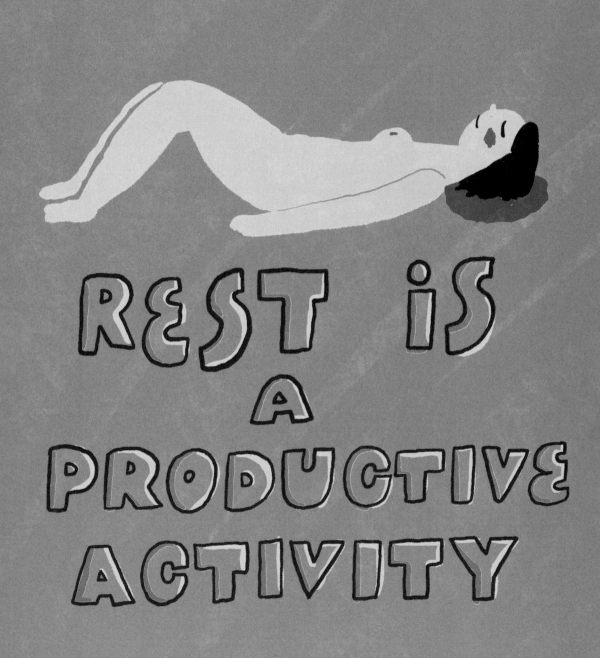

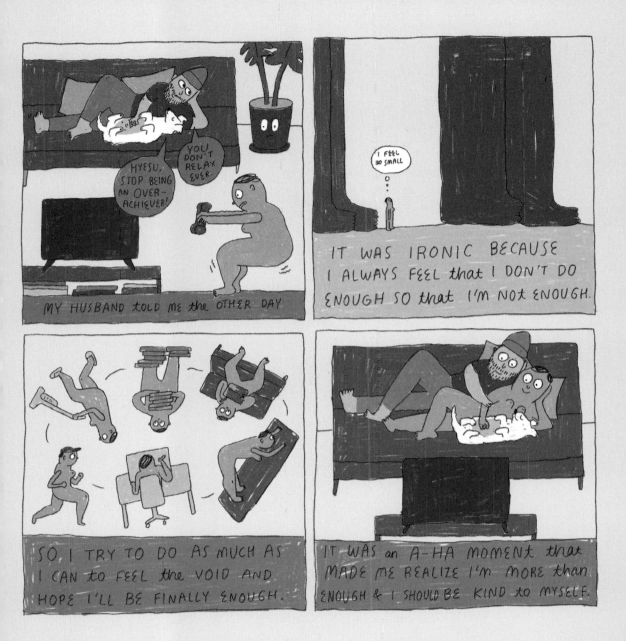

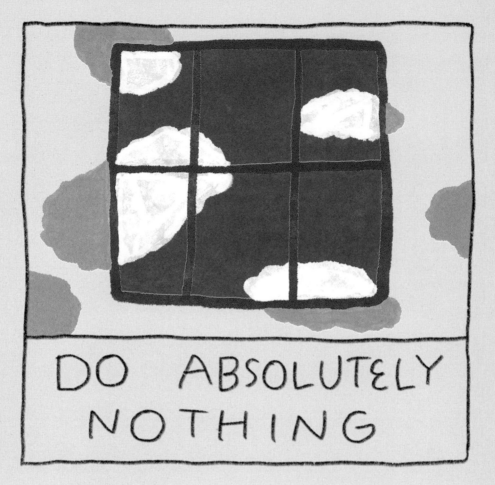

DO ABSOLUTELY NOTHING

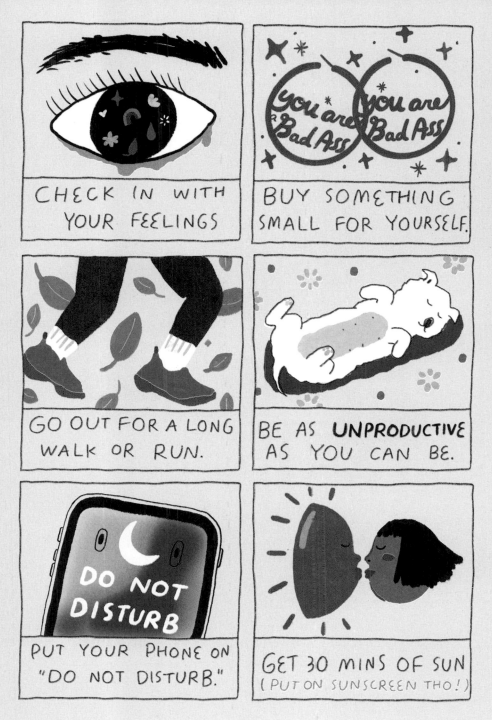

CHECK IN WITH YOUR FEELINGS

BUY SOMETHING SMALL FOR YOURSELF.

GO OUT FOR A LONG WALK OR RUN.

BE AS **UNPRODUCTIVE** AS YOU CAN BE.

PUT YOUR PHONE ON "DO NOT DISTURB."

GET 30 MINS OF SUN (PUT ON SUNSCREEN THO!)

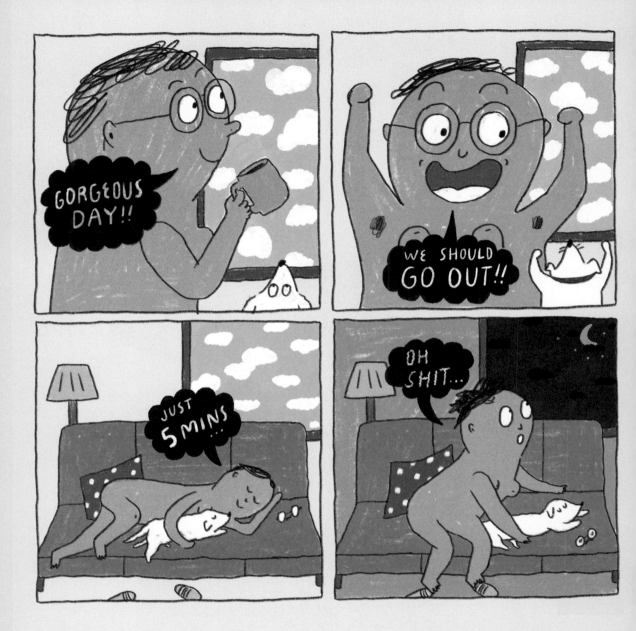

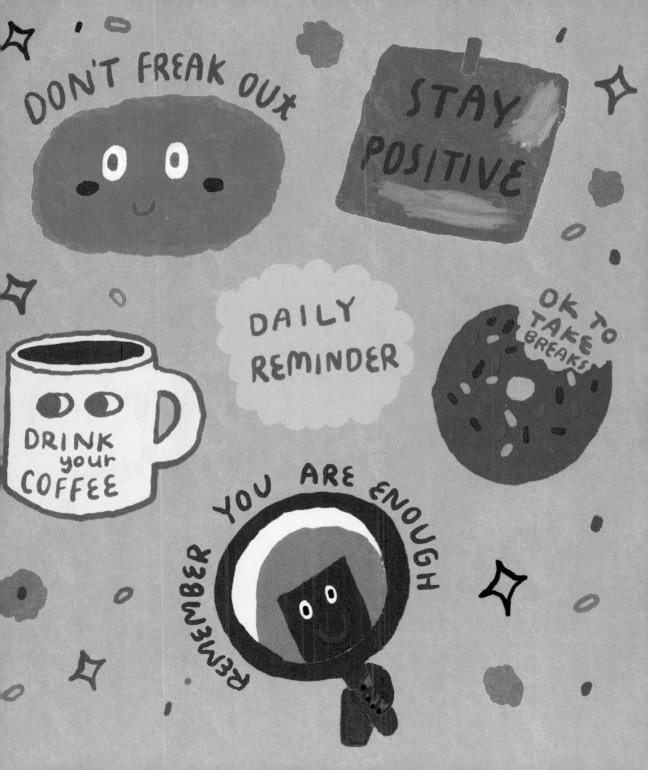

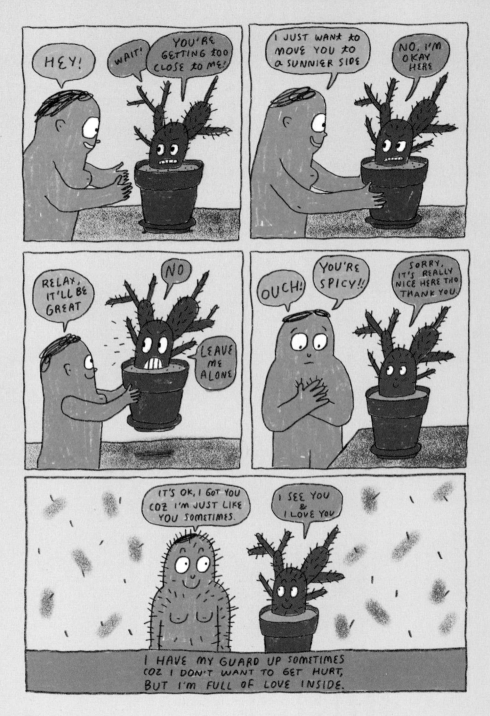

18

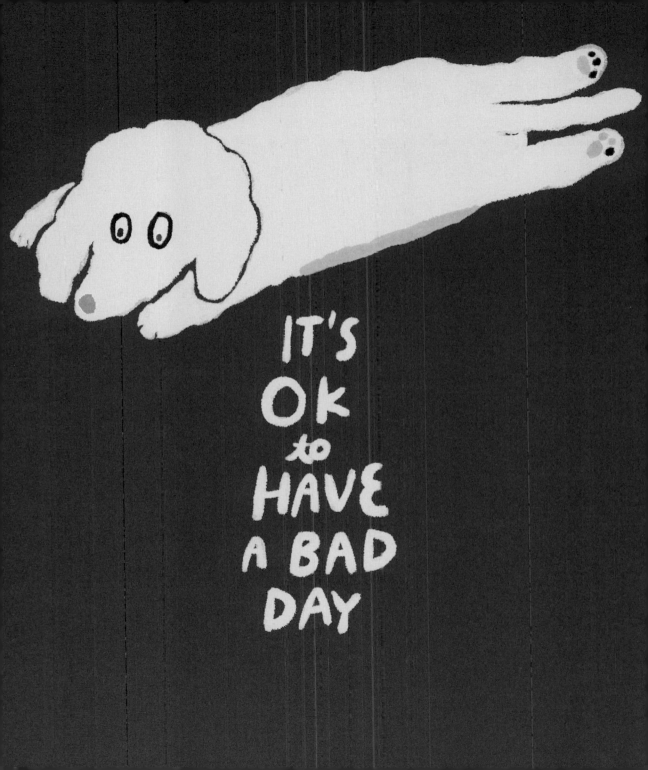

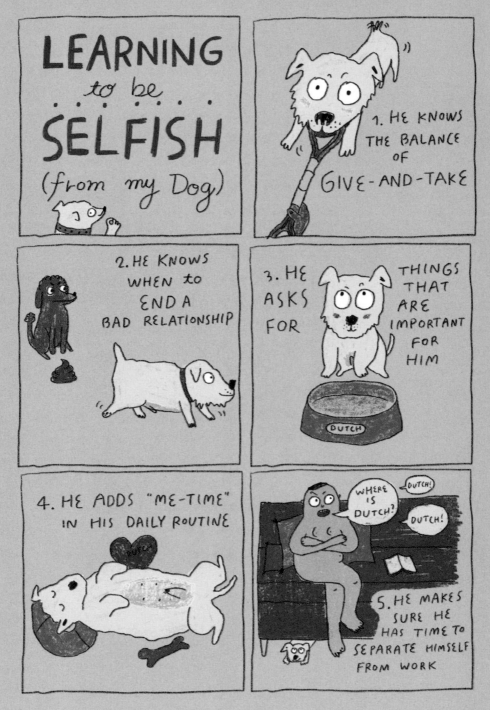

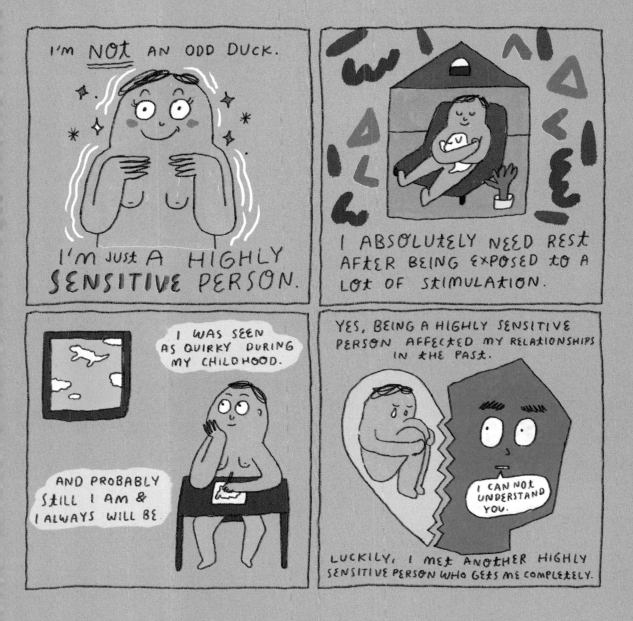

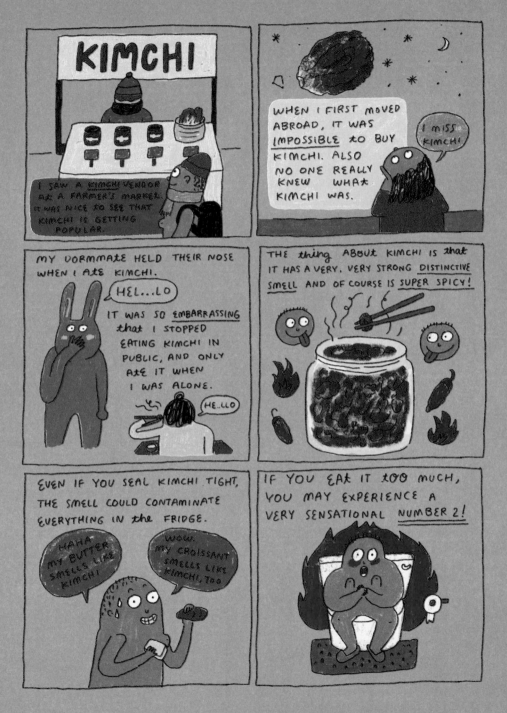

WHEN I WAS LITTLE, I OFTEN STAYED WITH MY GRANDMA DURING SCHOOL BREAKS.

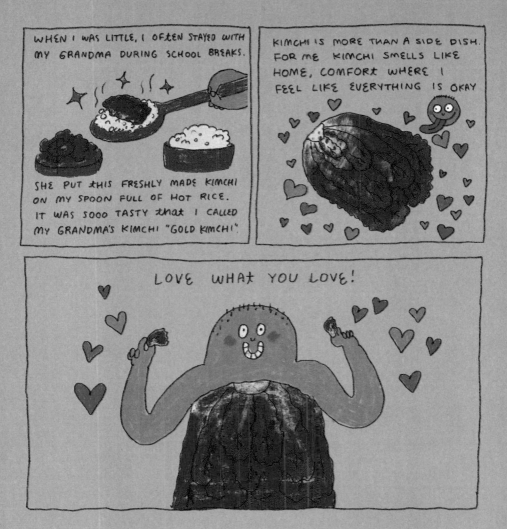

SHE PUT THIS FRESHLY MADE KIMCHI ON MY SPOON FULL OF HOT RICE. IT WAS SOOO TASTY that I CALLED MY GRANDMA'S KIMCHI "GOLD KIMCHI".

KIMCHI IS MORE THAN A SIDE DISH. FOR ME KIMCHI SMELLS LIKE HOME, COMFORT WHERE I FEEL LIKE EVERYTHING IS OKAY

LOVE WHAT YOU LOVE!

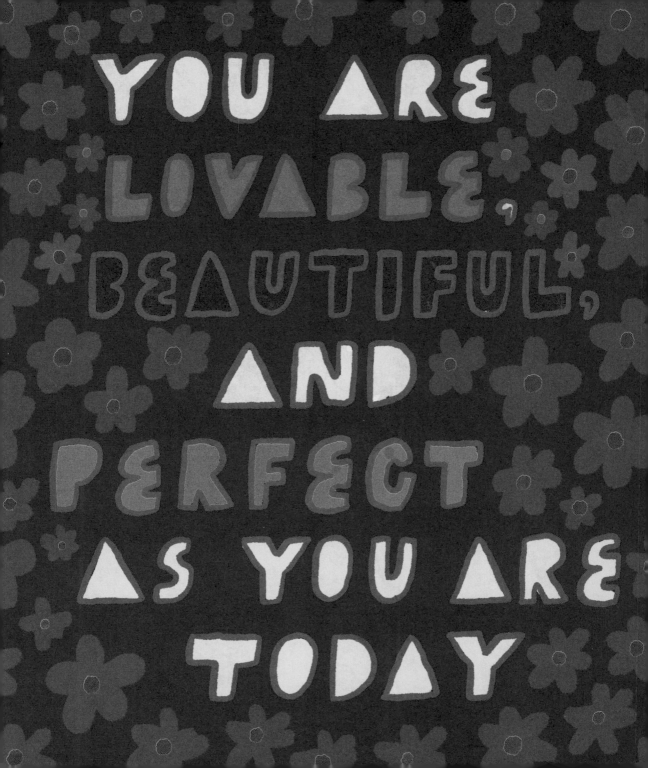

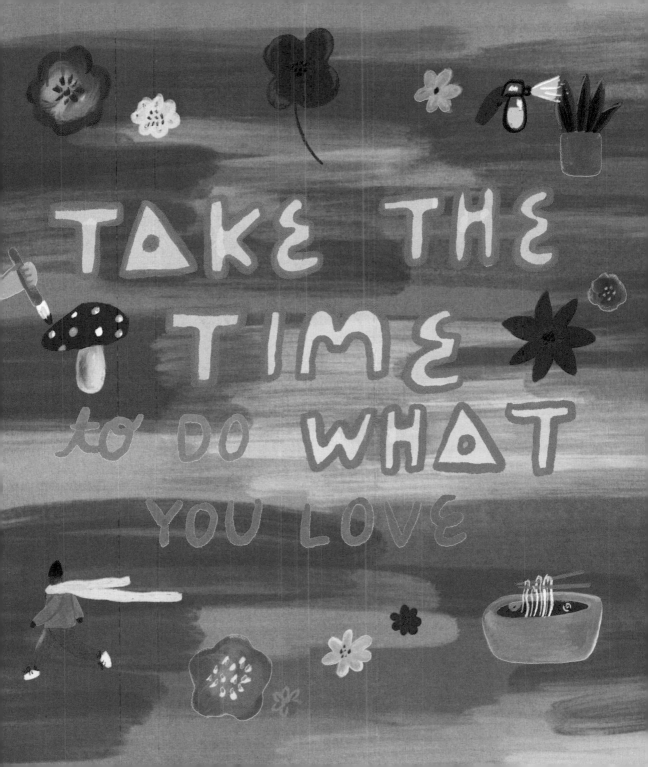

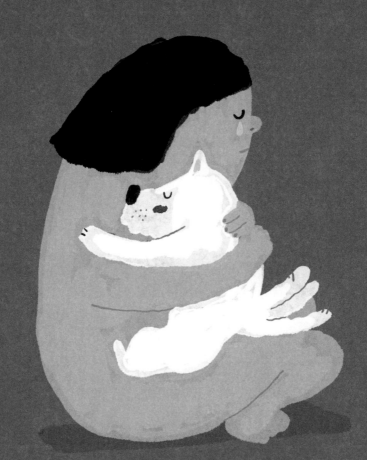

BE GENTLE WITH YOURSELF,
YOU'RE DOING THE BEST YOU CAN

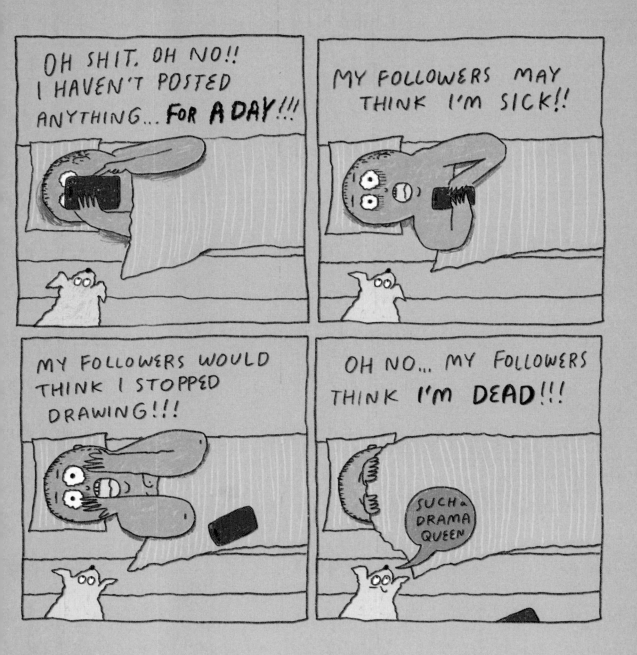

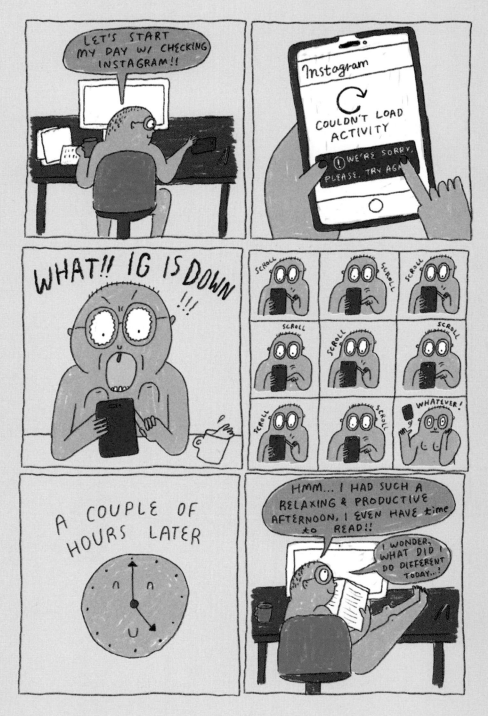

28

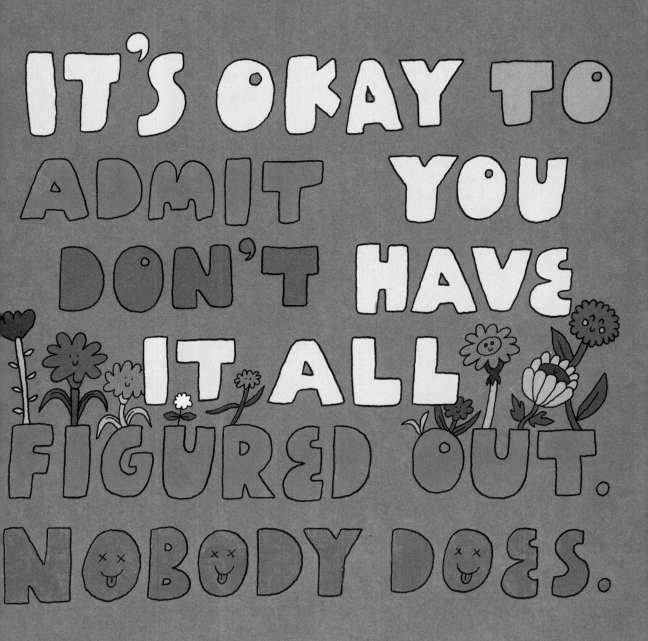

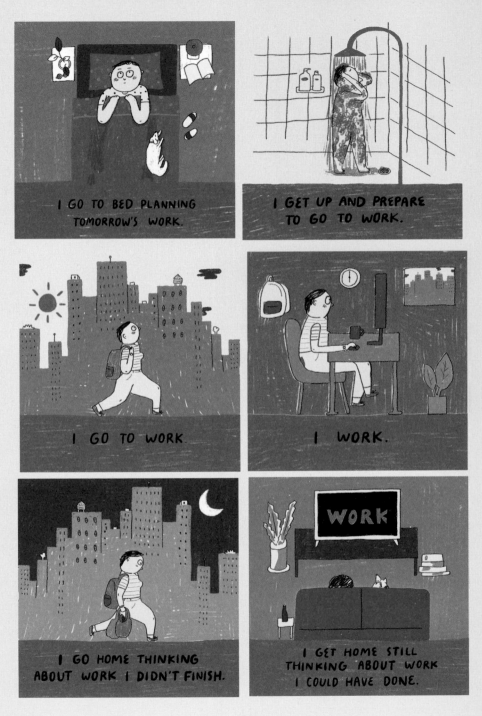

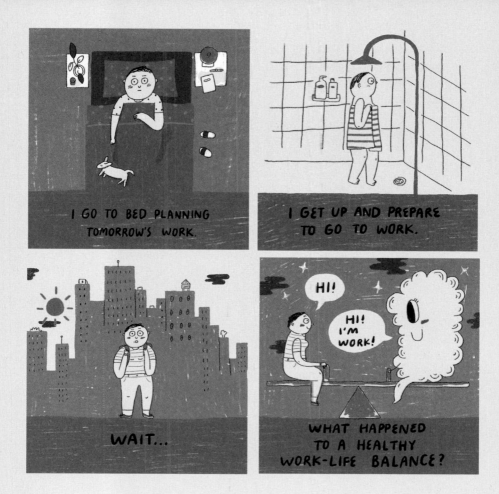

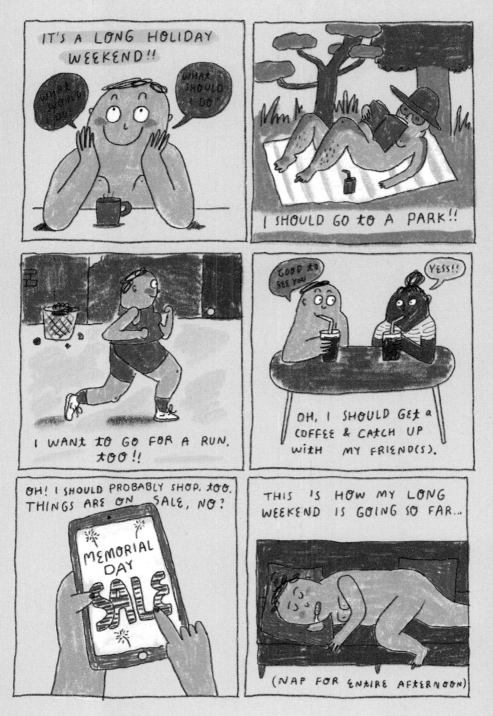

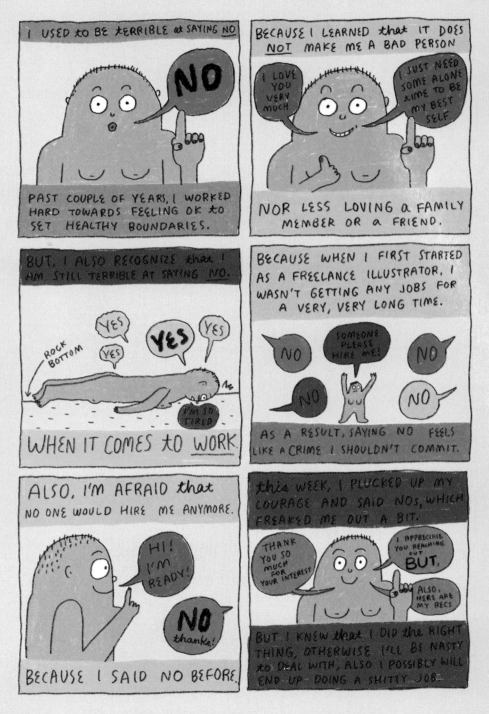

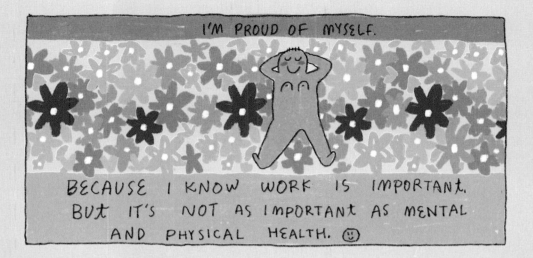

TAKE A MOMENT TO APPRECIATE HOW FAR YOU'VE COME.

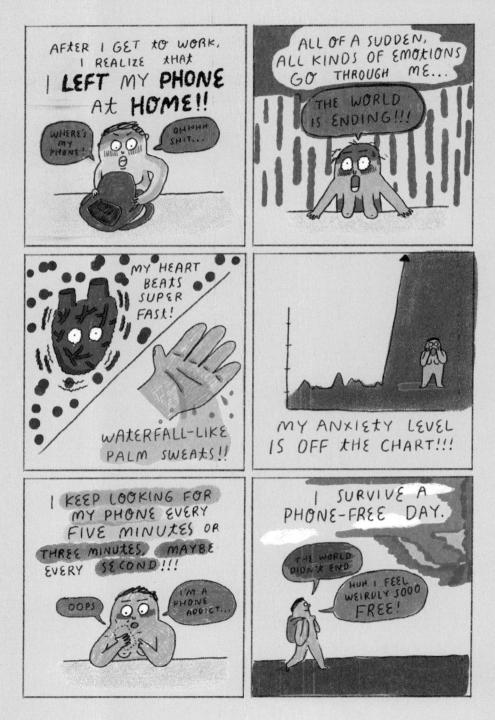

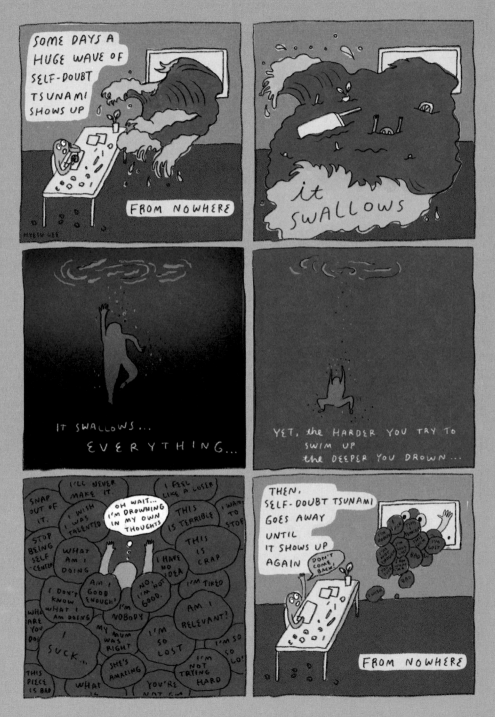

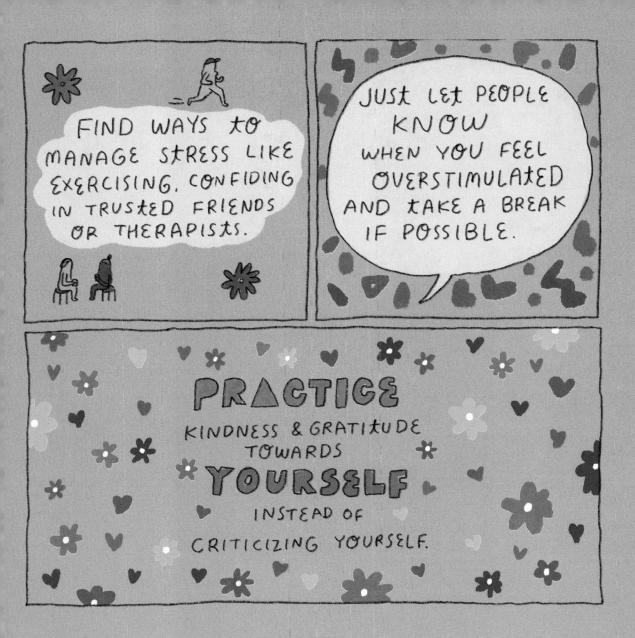

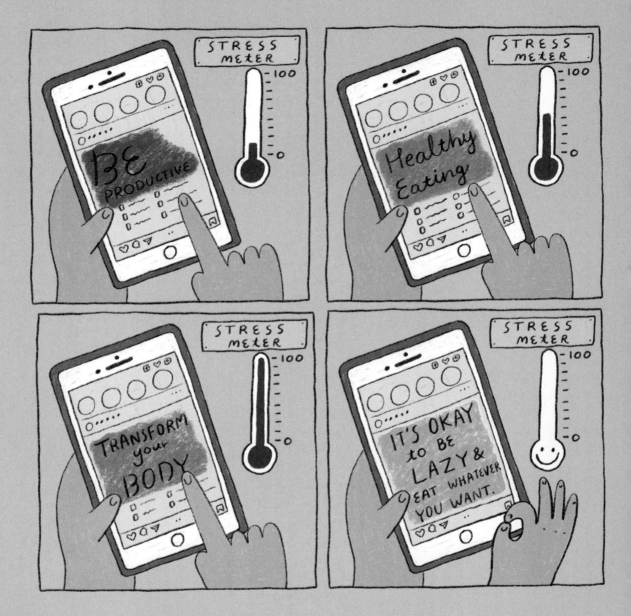

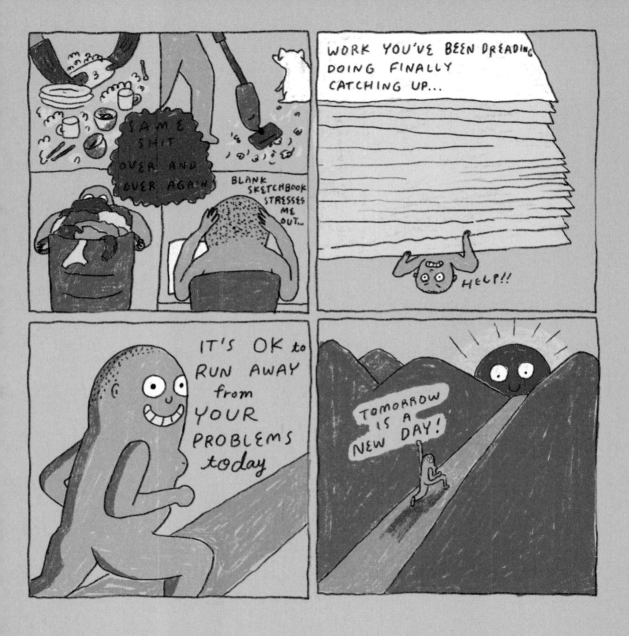

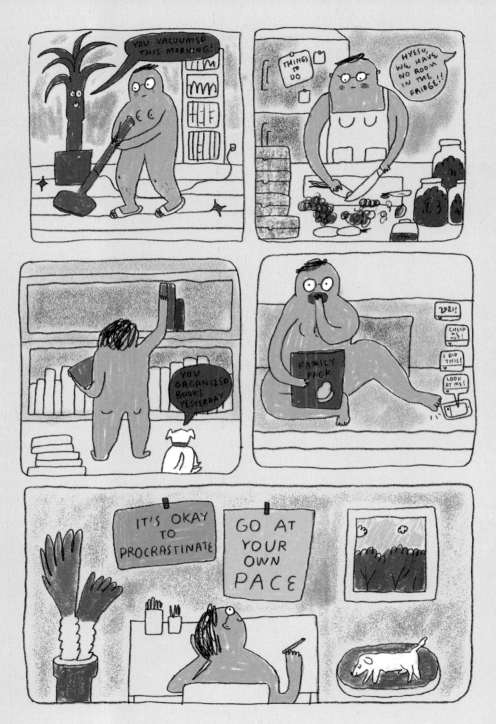

KEEP TAKING TIME FOR YOURSELF UNTIL YOU ARE YOU AGAIN

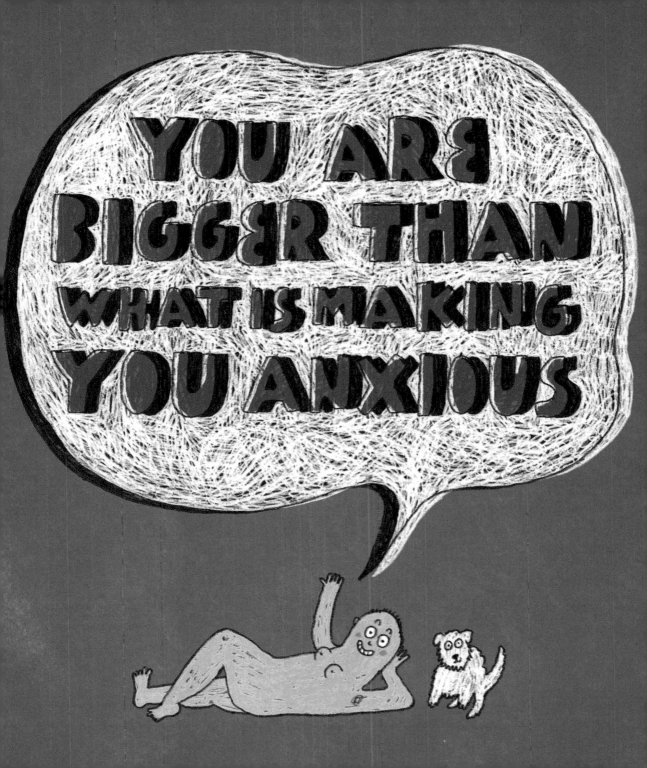

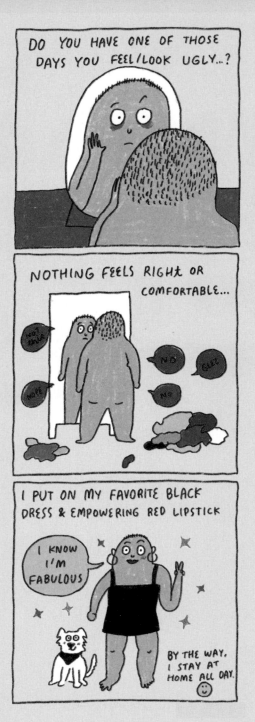

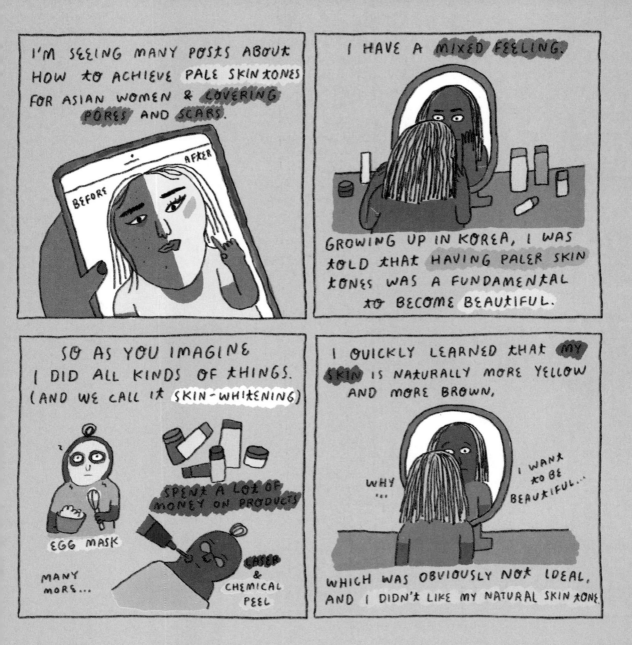

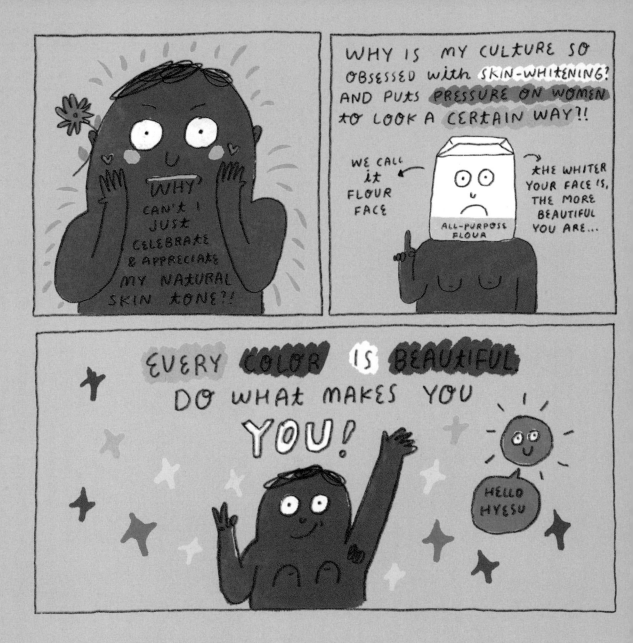

IT'S OKAY IF IT'S TAKING MORE TIME THAN YOU THOUGHT

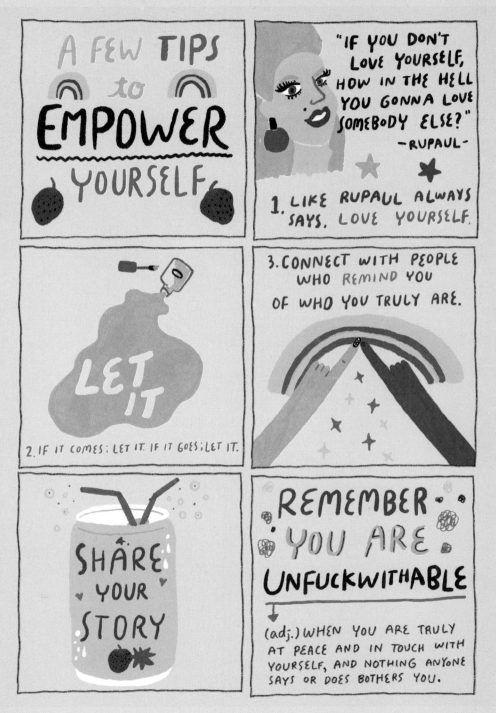

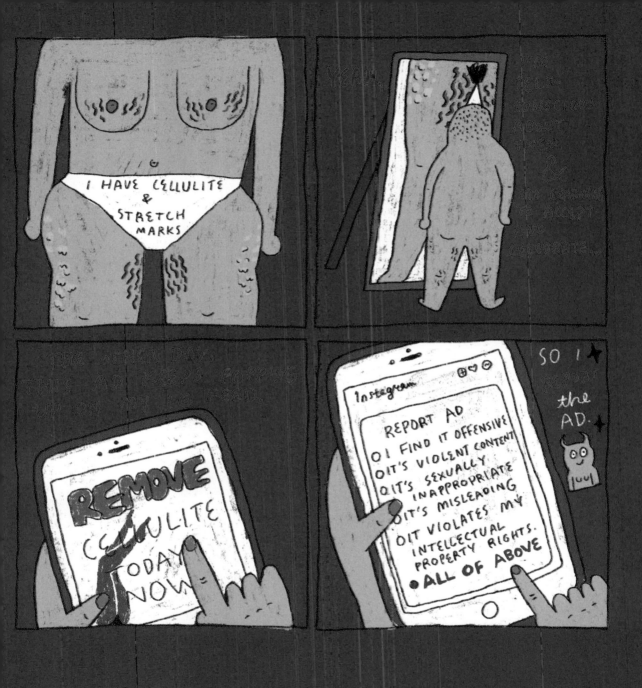

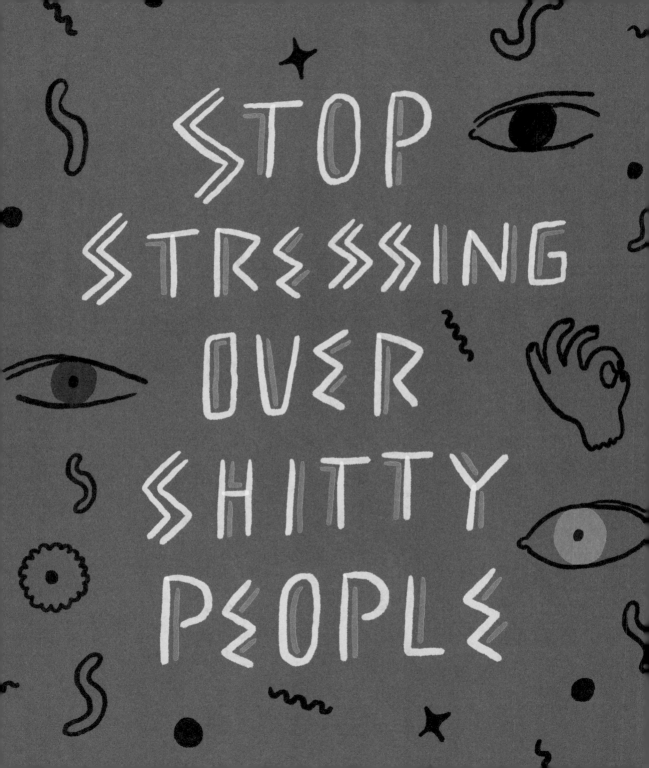

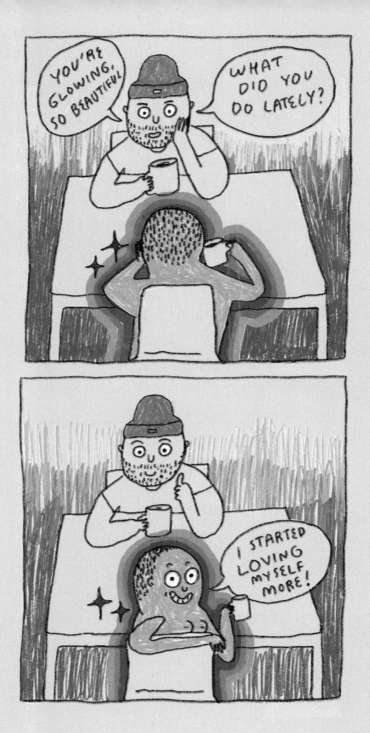

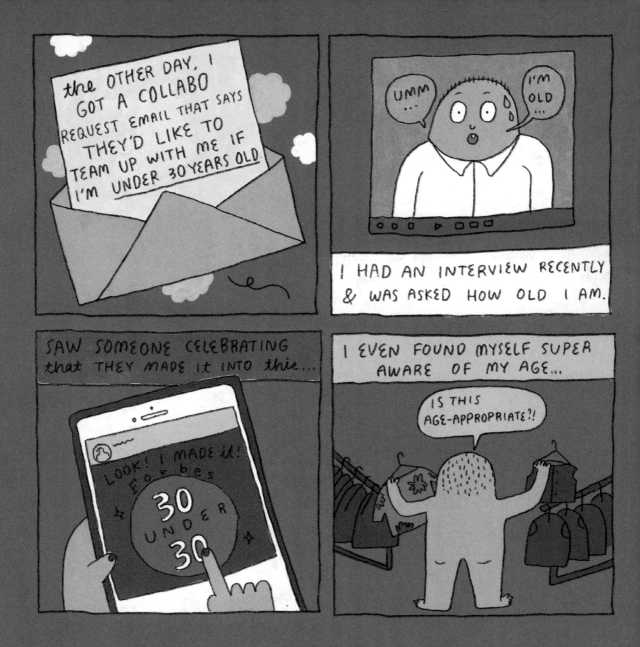

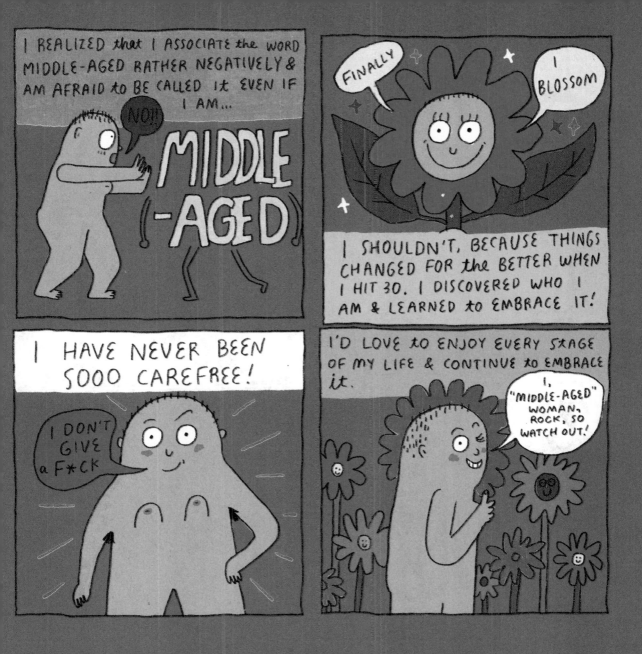

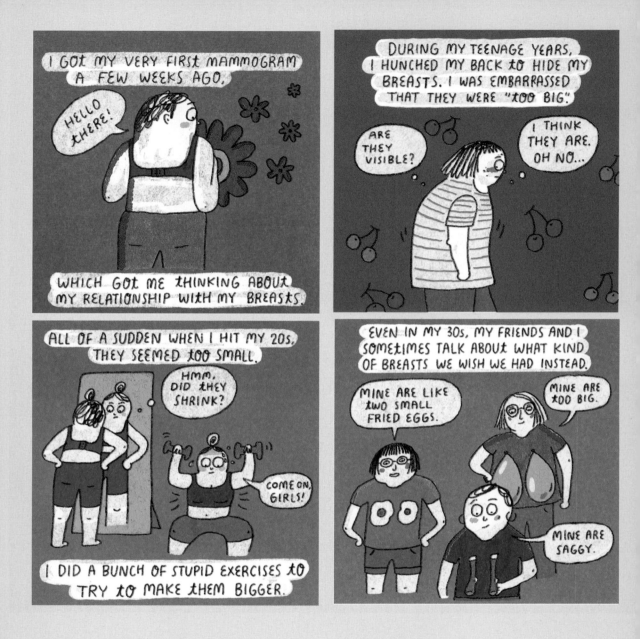

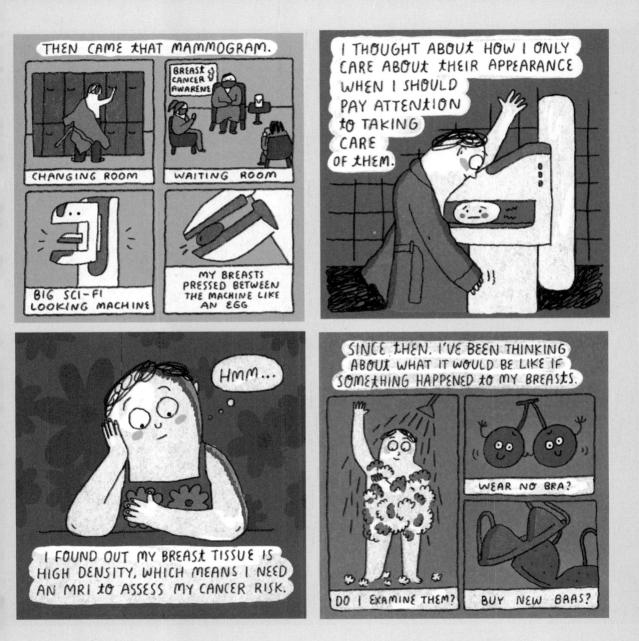

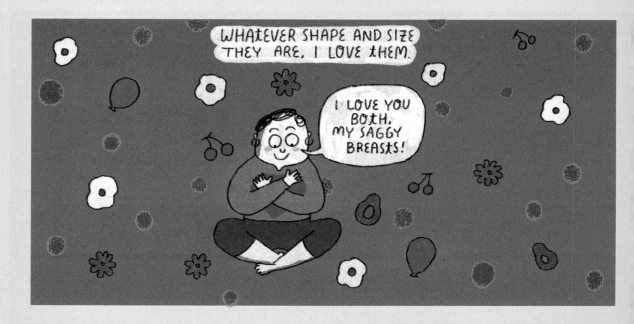

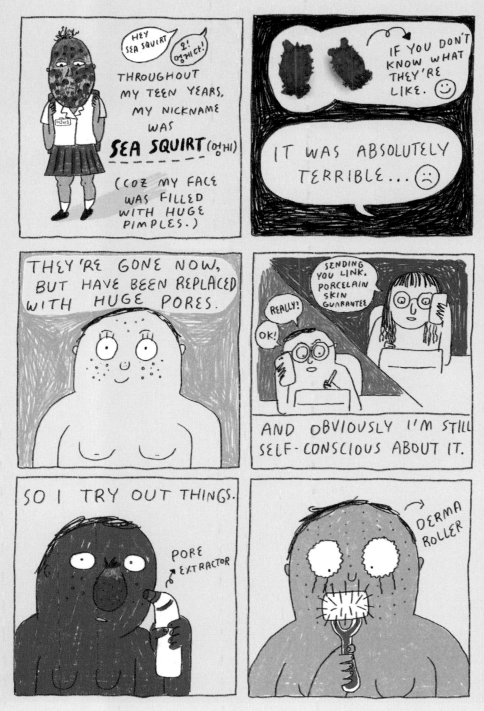

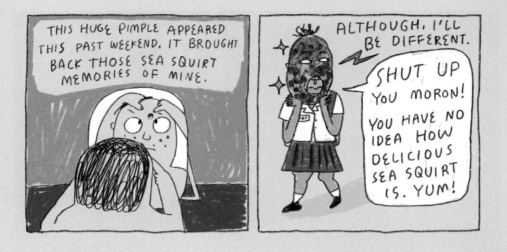

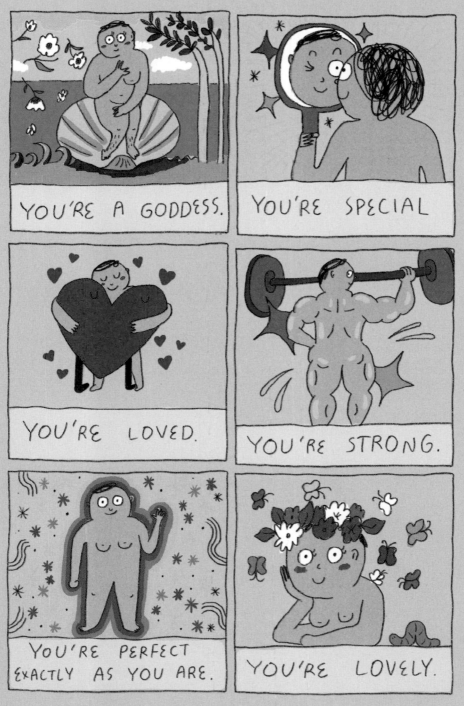

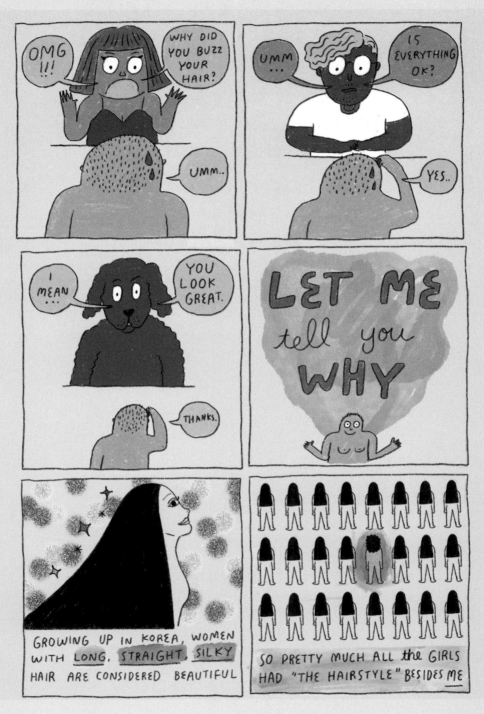

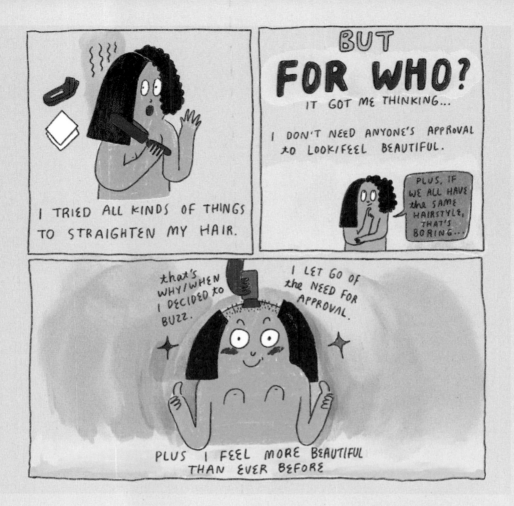

YOU DON'T HAVE TO HAVE IT ALL FIGURED OUT TO MOVE FORWARD.

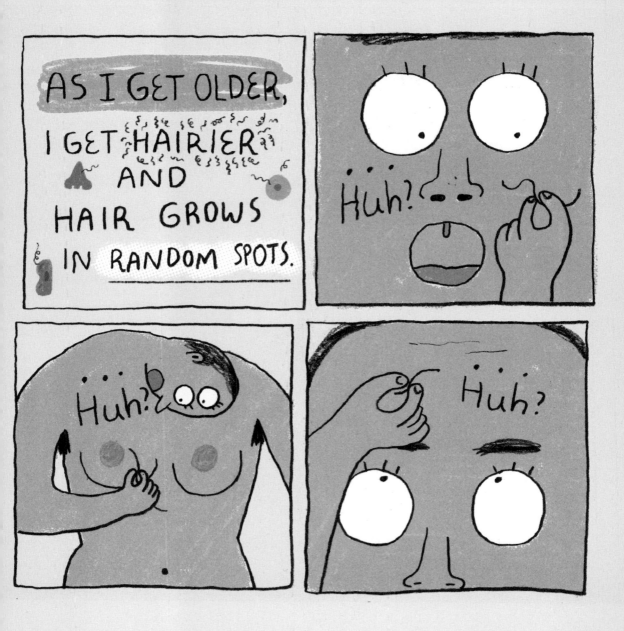

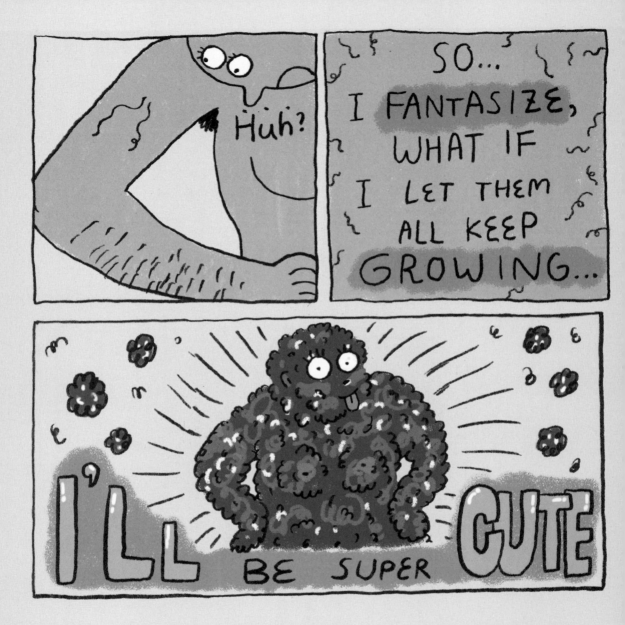

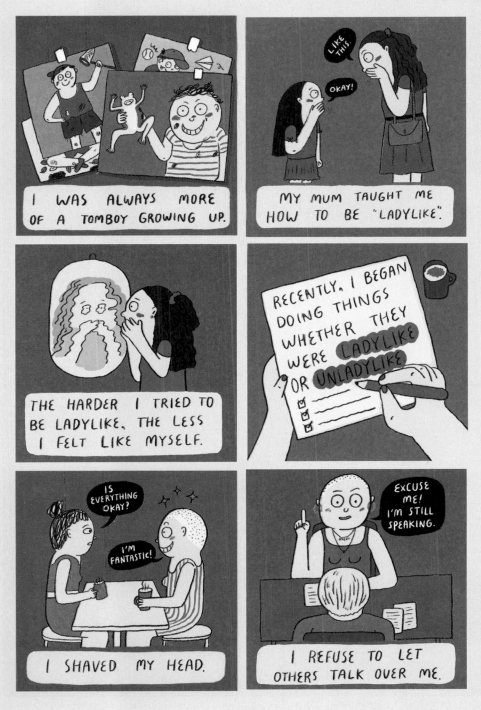

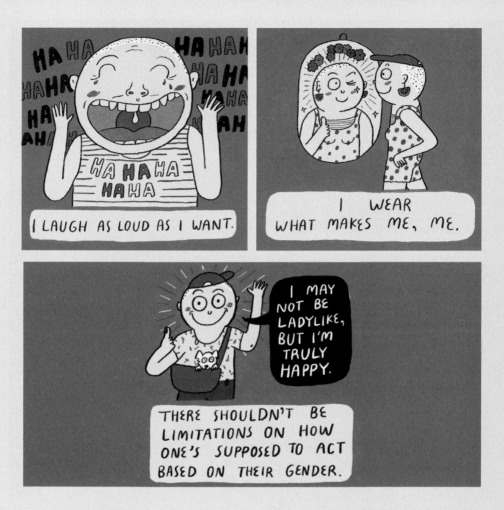

IT'S OKAY to LIVE A LIFE OtHERS DON't UNDERSTAND.

STOP TRYING TO BE LIKED BY EVERYONE
YOU DON'T EVEN LIKE EVERYBODY

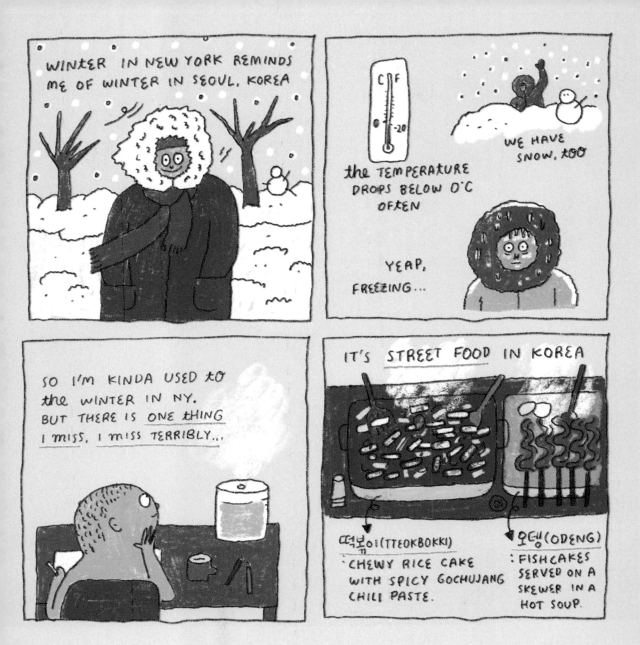

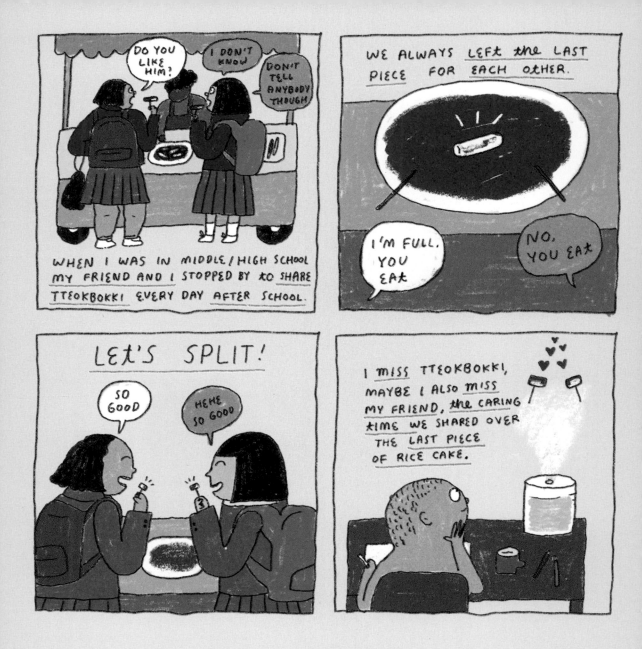

CONNECT with PEOPLE WHO REMIND YOU OF WHAT YOU TRULY ARE

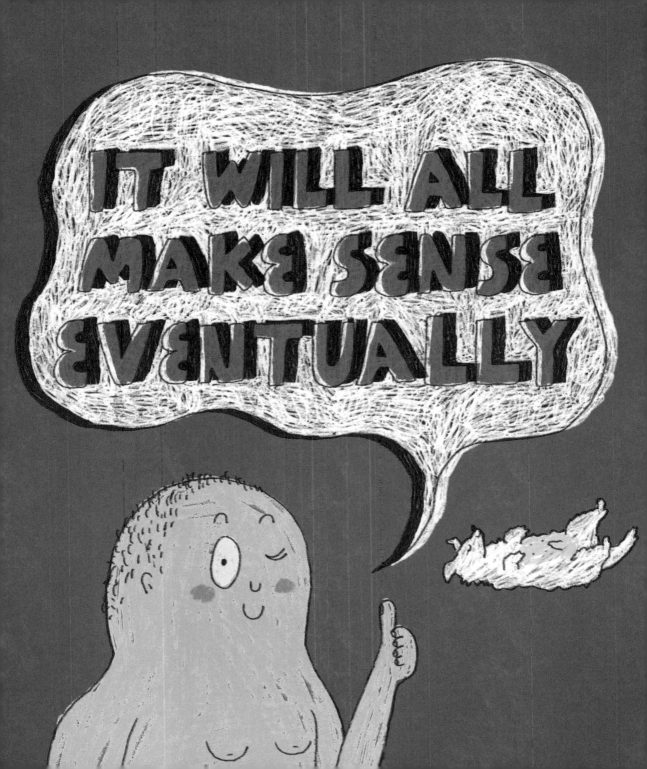

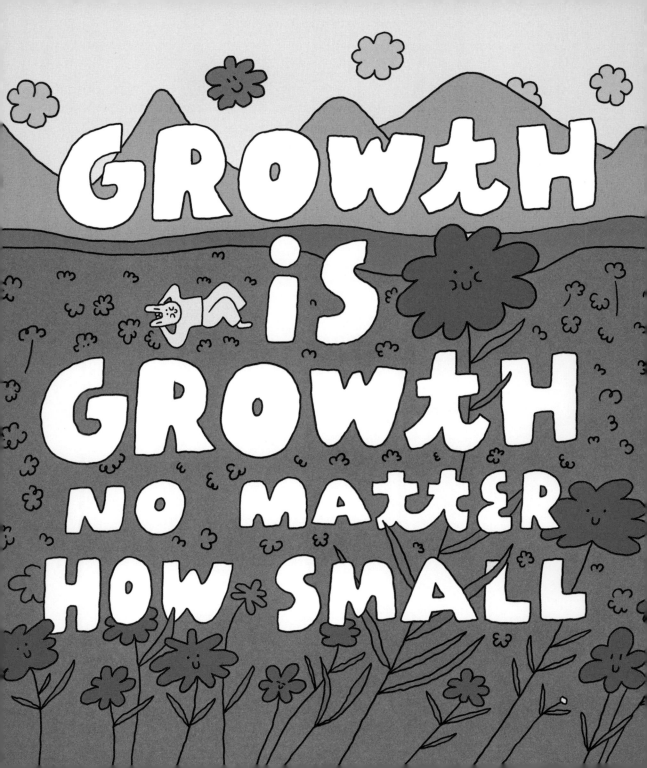

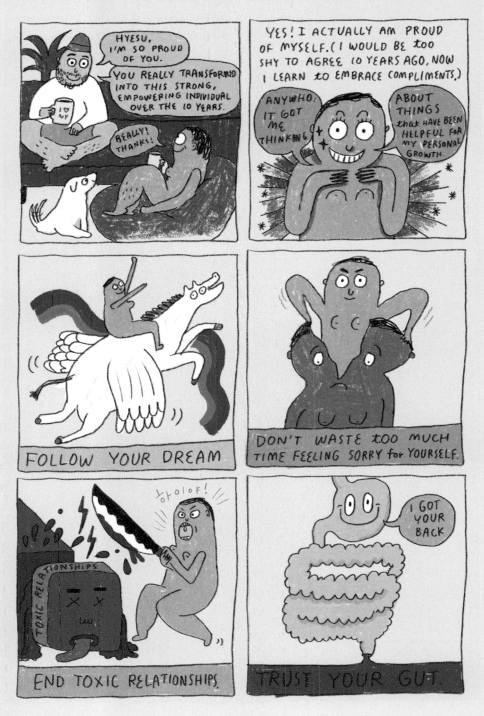

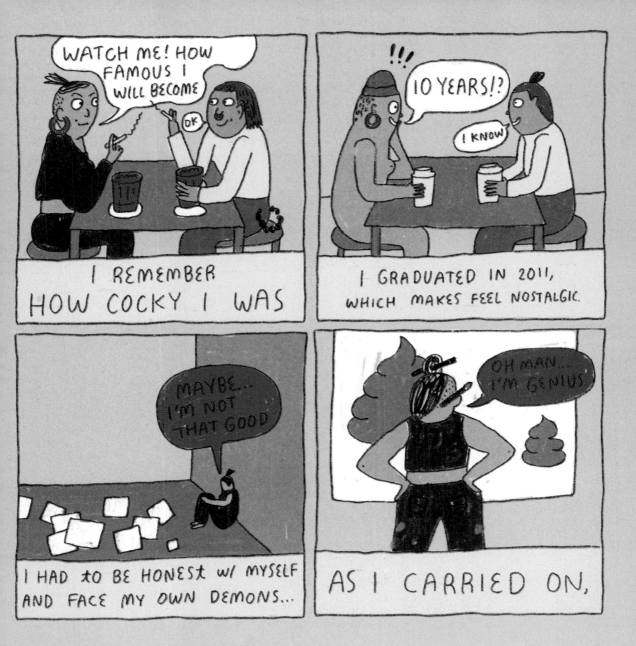

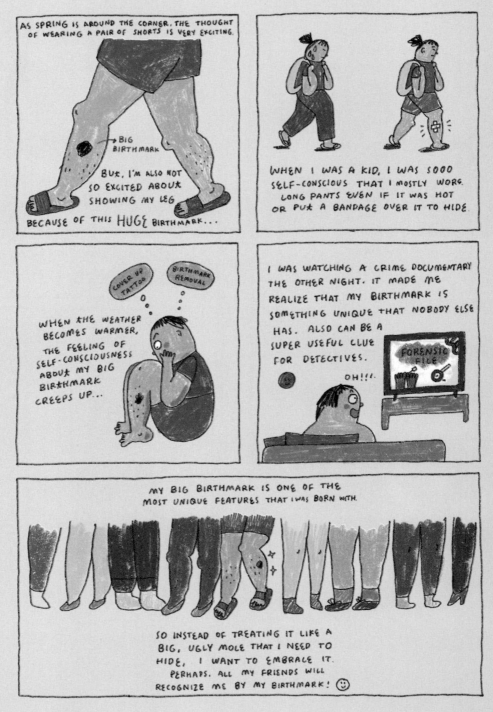

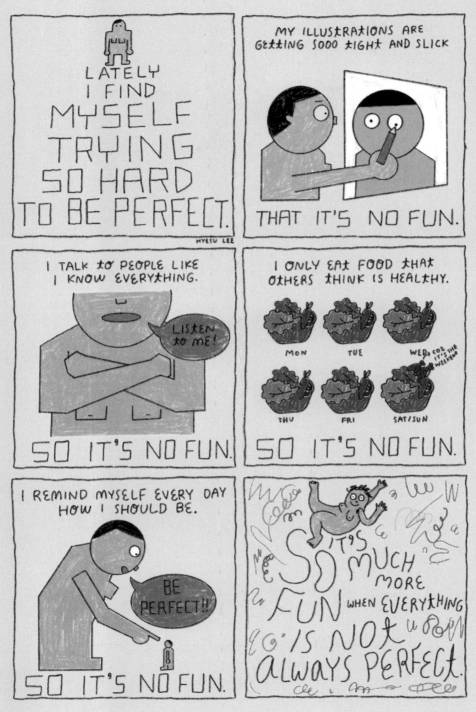

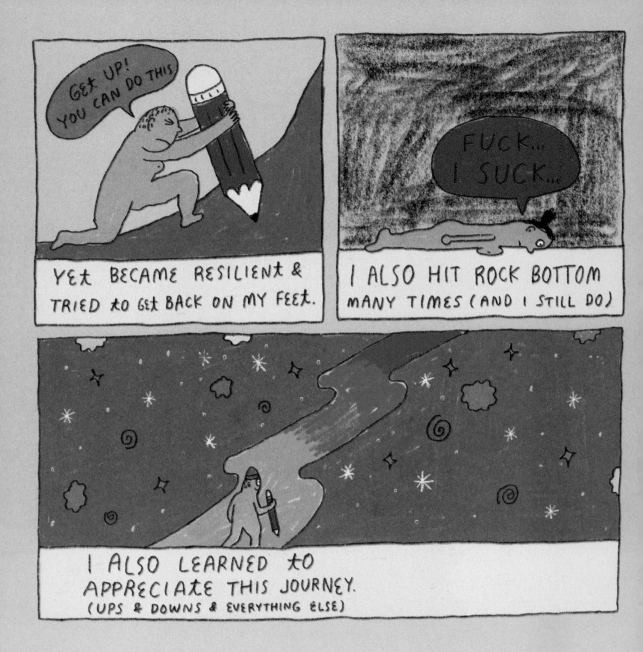

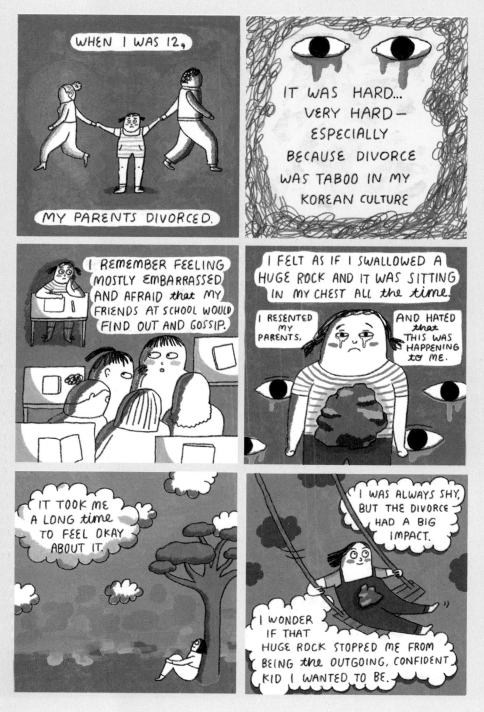

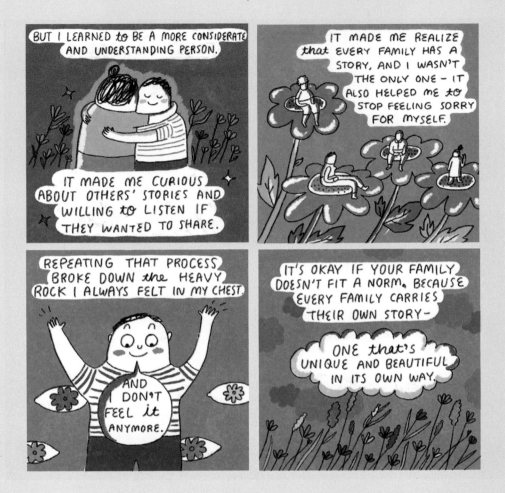

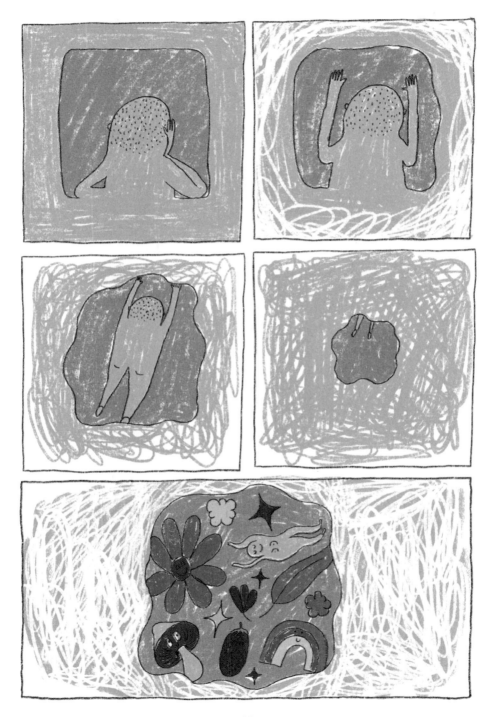

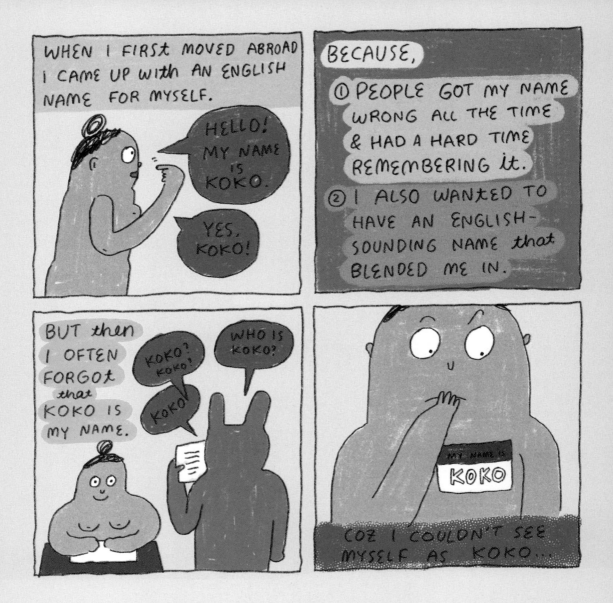

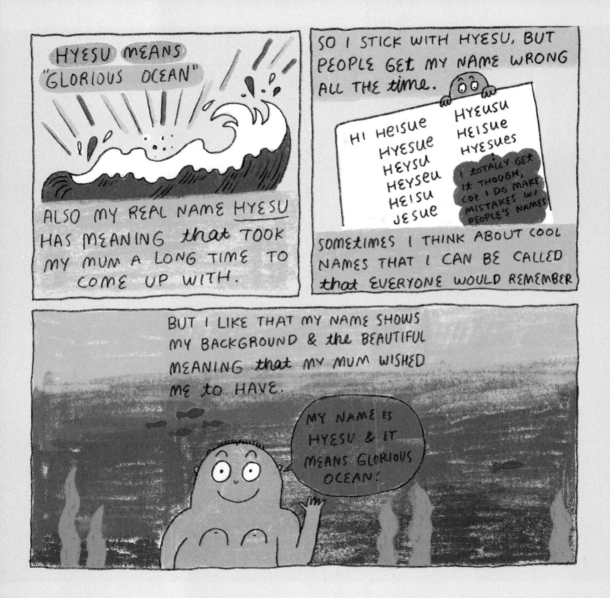

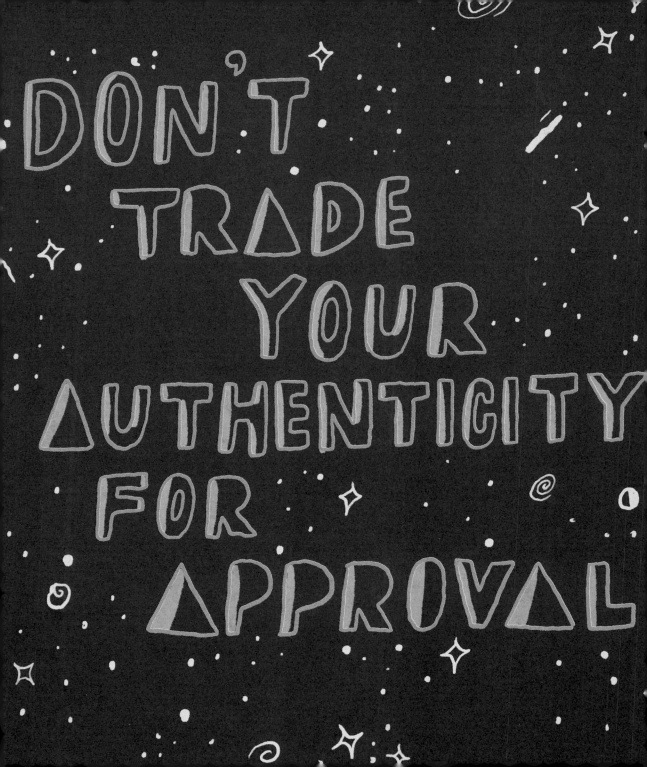

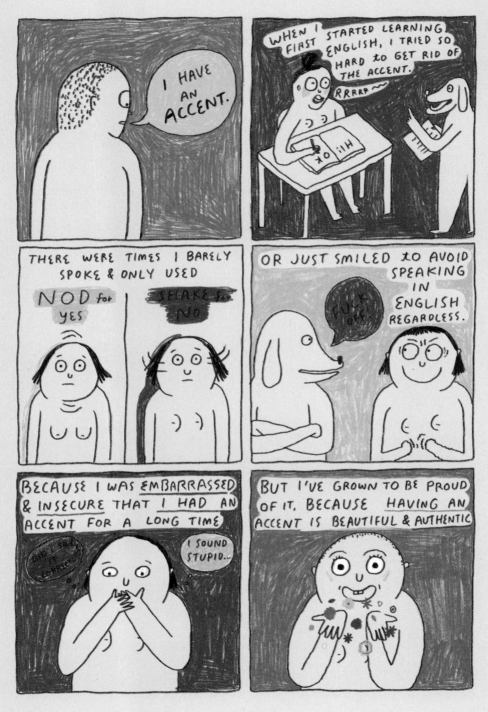

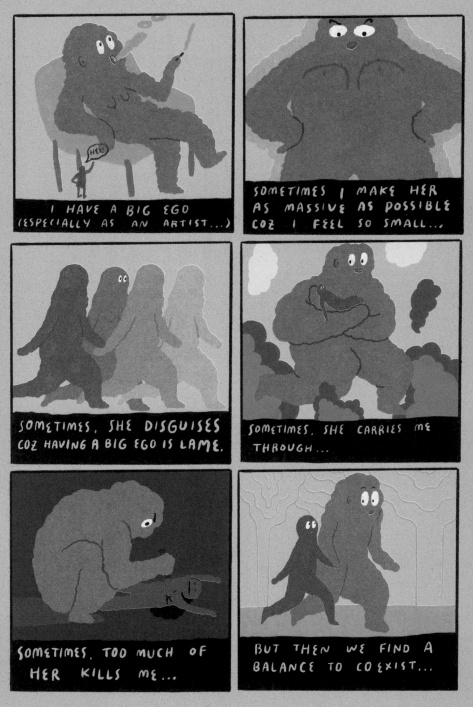

NEVER REGRET

IF IT'S GOOD. IT'S WONDEFUL

IF IT'S BAD, IT'S EXPERIENCE

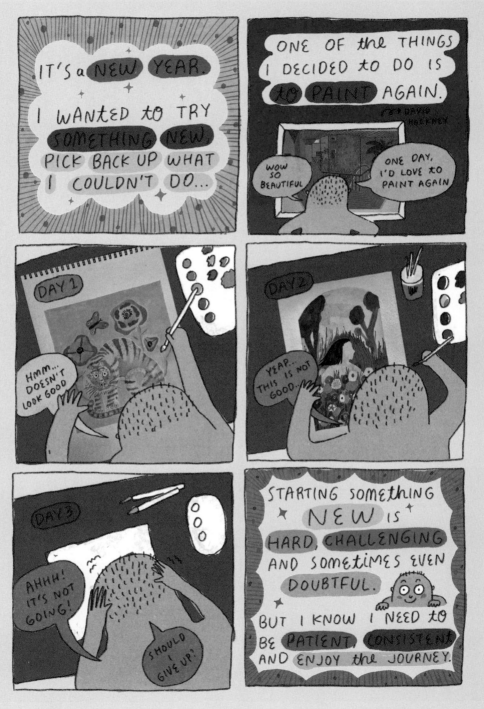

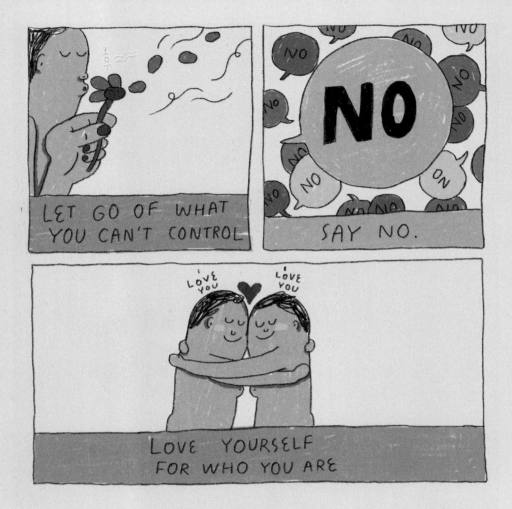

WHAT'S MEANT to BE
ALWAYS FINDS A WAY.